WHAT'S A FEIS?

An Irish Dance Memoir

AISLING O'CONNOR

DENVER, COLORADO

*For my
Daughter
"Bridget"
I am so proud of you!*

* Disclaimer: Although this is my true story the names have been changed to protect the innocent and to add a wee bit of mystery.

Table of Contents

What's a Feis?

IT WAS MARCH 1996 and Riverdance was a worldwide sensation. I had heard of Riverdance but never paid any attention. My daughter Bridget and I were sitting on the front porch after school one day when Molly and her mom were walking by on their way to the YMCA for swim classes.

Molly could hardly contain herself, "I won first place at the Feis!" she exclaimed. Bridget and I exchanged puzzled looks.

"What's a Feis?" Bridget asked. And that was the beginning of a love that would last a lifetime. Molly explained to us that she was an Irish Dancer. Although I am of Irish descent, I didn't know anything about Irish dancing, and Molly's comment piqued my curiosity. As a teenager, my grandmother from Sligo Ireland, jumped on a boat, and ended up in Brooklyn through Ellis Island. Despite my grandmother's origins, there wasn't much mention of our Irish heritage when I was growing up. My only fuzzy memory of "being Irish" was at a family gathering. Grandma, scotch glass in hand, showed me a few Irish dance "steps." I watched her with her hands on her hips, swinging her foot back and forth, but I am sure she had never taken a class in her life. Maybe it was

just the scotch that day.

Molly's mom explained that there were Irish dance classes in a town just a few miles away and she said that Bridget should sign up. She also mentioned that Riverdance was on tour in New York City. As we talked, I glanced over and saw Molly showing Bridget some steps. Shortly after, Molly and her mom went off to the YMCA and Bridget and I went inside. As I started to prepare for dinner, I noticed Bridget dancing around the kitchen. She had already mastered the steps that Molly had shown her. I was peeling a potato over the sink and felt a tug on my shirt.

She looked up at me with earnest intention, "Do you think I could take Irish dance lessons like Molly?" I could sense the excitement in her eyes, so I promised to check into it the next day.

As we got ready for school the next morning, Bridget was already asking me when she could Irish dance. I sent her off to school and put the tea kettle on. Sipping my Barry's Irish Tea, I called the Irish Dance School that Molly attended. A delightful voice greeted me on other end of the line. Ms. Deirdre introduced herself as the owner of the school. She explained to me that she began dancing at the age of three and eventually started her own school in her garage! We made a date to visit a class on Tuesday. Feeling lucky, I dialed Ticketmaster and managed to book three tickets to see Riverdance at Radio City Music Hall in New York City. *Bridget will be so excited*, I thought. (I wanted to do a jig myself, after scoring those tickets).

The day dragged on forever in anticipation of telling Bridget the big news. When I picked Bridget up from school that afternoon, she came flying through the doors, still Irish dancing! She was smiling from ear to ear, her two front teeth missing.

"WELL? AM I going to Irish dance lessons?" she shouted out as soon as she saw me.

I was beyond giddy to tell her about our appointment on Tuesday, and as soon as I did, she began jumping up and down with excitement. I added that I had another surprise for her--we were going to see Riverdance over the weekend. She stopped jumping immediately, eyes and mouth wide.

She thought for a long moment and quietly said, "R-E-A-L-L-Y? Riverdance?" I shook my head and gave her a big hug. She skipped away, still smiling her toothless smile, Irish dancing all the way home. In the distance, I could hear her singing "I'm going to be an Irish Dancer!"

It was a long week. Bridget was so excited—she could hardly sleep Friday night. She was dancing around the house as we got ready Saturday morning. On the train ride to New York City, I remember watching her look out the window, all dressed up for her special day, thinking to myself, *What is this 'Irish Dance' all about? Who is this Michael Flatley anyway? What have we gotten ourselves into?*

As we sat in our orchestra seats, Bridget's eyes were as big as saucers. When the curtin finally went up, the lean dancers in black shoes caught our attention instantly. Then it started— the taps, the loud beats, the excitement—it was amazing! *How do they do that?* I thought to myself. I loved the Irish music.

When Bridget saw *the* lead dancer flying around in her soft shoes, she exclaimed, "That's what I want to do! I want to be an Irish Dancer just like her!" I knew just then that something special was going on here, and she hadn't even had a class yet! After the show and a quick trip to the gift shop, with a Riverdance poster tucked under her arm, Bridget danced all the way to the train. Exhausted from the

excitement, she slept the whole way home. After tucking her into bed that night, I taped her Riverdance poster on the wall, and as I turned off the light, I could still hear the sound of the hard shoes in my head.

Tuesday was finally here. When I picked her up from school, she told me she had been practicing a lot since we saw Riverdance. She was so serious for a five year old; I had no doubt that she was ready! The ride to the dance school seemed to take forever with all the traffic. The studio was on the second floor of a house just outside of town. I parked around the corner, and as I was putting the money into the meter, I saw Bridget dancing down the street. The house was old, and the porch creaked with each step. Right inside the door were steep stairs leading up to the studio. I noticed a half-dozen moms sitting in folding chairs along the hallway. An assistant came over to greet us.

"I'm going to be an Irish Dancer!" Bridget exclaimed. Just then, Molly came over and took her by the hand, leading her to the classroom. The assistant told me that the class was an hour and I could either stay or come back. I sat down and listened to the sounds inside. "Hop-two-three" said Ms. Deirdre. I heard lots of giggles. I peeked inside. The room was large with old wood floors, mirrors and ballerina Barres lining the walls. I saw about fifteen other little girls, all Bridget's age, dancing around. They seemed as serious as Bridget was about what they were doing. The hour seemed to go by very quickly. Finally, the door opened and one by one, the little girls met with their moms and left. Molly came out and told me that Ms. Deirdre wanted to speak with me. I noticed that Bridget was the last one in the room and Ms. Deirdre was still watching her dance about.

"You must be Bridget's mom," Ms. Deirdre said. "What

school has she been dancing with? She is very good." Baffled, I said that she had never had a class before! Ms. Deirdre looked surprised and with a very big smile on her face she said, "Mrs. O'Connor, I hope you have lots of money! You have a talented little Irish Dancer here!"

Bridget held my hand tightly, talking all the way to the car about her class. Our next stop was the Irish Shop in town that sells "soft shoes." On the way there, I was thinking about what Ms. Deirdre said. *What in the world would I need a lot of money for??*

The First Year

TUESDAYS NEVER SEEMED to come quickly enough. Bridget danced all the time--in the house, on the way to school, in the food store, everywhere. One day at McDonald's, I noticed her watching herself dancing in the security camera on the wall. A hush settled over the area, and that's when I realized that the four lines of people and the workers were watching her. She must have felt all of the eyes on her because as she turned to the crowd, she giggled and ended with a bow and a big smile on her face as the "audience" erupted with thunderous applause. It was funny.

The end of the school year was already approaching. There was something called a "Ceili" coming up—a sort of recital with beer and dancing, someone said. I was told to dress Bridget in a plaid skirt and a white dress shirt and to get a pair of "poodle socks" at the Irish shop where we bought her dance shoes. *What do poodles have to do with Irish dance?* I wondered.

We invited Daddy and Grandma and Grandpa to the Ceili. There were probably two hundred people there, all settled at their tables. Food was everywhere. Beer cans and beer bottles

were piled sky-high near the garbage bins. Kids were dancing and running around as parents danced and sang along to the loud Irish music. Everybody was happy. An hour into things, the children put on a little show with the beginners starting first. Bridget looked so cute in her little outfit up in the line, arms straight at her side with a huge smile on her face, still missing her two front teeth. After she danced with her beginner group, Ms. Deidre had her dance again with a few other groups. Bridget had a great time and we were all proud.

After the younger groups finished, it was time for the older dancers to perform. They all had on the same poodle socks and long curly hair as Bridget. The dresses were bold and bright with three panel skirts, stiff as a board. They were embroidered with beautiful Irish designs--birds and dragons, swirls and Celtic knots, beautiful lace collars and lace sleeve cuffs. I wondered how much they cost and if that was what Ms. Deidre said I needed a lot of money for. Bridget ran up in front, sat on the floor, legs crossed, and watched in awe as they did their part of the show. When they were done, she quickly got up, ran over to me, and asked when she could get a dress like theirs. I told her she would have to earn it. "I can't wait," she said with a smile.

CHAPTER

The First Performance

BRIDGET WAS A Girl Scout. Her Brownie Troop was having an end of the year party, and everyone had to do something to contribute. She told her leader she would Irish dance for everyone. I was surprised that she had such confidence already and that she loved to perform so much. I dressed her in the white button down shirt, a new plaid skirt, poodle socks, plus a brand new pair of soft shoes since she had already grown out of the first pair. The "stage" was the Troop Leader's backyard, along the driveway. Bridget had her little boom box and her music in her hand. She handed it to me with instructions. Everyone settled around her. I got a little nod from her to start the cassette tape. She stood tall, with her arms straight at her side, foot pointed, waiting for the music to start. At the right moment, she started to dance, smiling and flying around the "stage." Everyone was quiet while watching her. I don't think anyone there had seen Irish dancing before. When the music was over, she surprised me with a bow to me, "The Musician," followed by a bow to the audience. Then, as if she were on stage with Riverdance, the crowd jumped to their feet, clapping and chanting for an encore. So she pointed her

toe, cued me to start the music again, and danced a second time. When she was done, all the little ones and their moms gathered around her, as if she were a star. I think she may have thought she was Jean Butler that day.

The First Feis

SUMMER WAS IN full swing and Ms. Deirdre told us that it was time for Bridget's first Feis. I remembered Molly explaining to us that first day that a Feis was a type of dance competition. Bridget was to wear her little white shirt, plaid skirt, and poodle socks again. I was told to curl her hair with curlers overnight than to be at Farcher's Grove at 8 am.

Bridget was quiet that morning. I think she was nervous. I wasn't sure what to expect either. We got there a few minutes before eight and parked in a grassy field alongside a picnic grove. As we passed the gates, I noticed that a lot of people had already arrived. We stopped at the table to pick up her number card, #533. I attached it with a safety pin to her skirt. The ground was dry. As we walked around looking for stage #1, we left a trail of dust behind us. When we finally found the stage, it was old and creaky looking. A few folding chairs were placed in front of the stage. I had a feeling that this Feis had been around for many years. The musician was off to the side with an accordion in his lap. An older woman checked Bridget's number and told her to line up with about ten other little girls. The musician started playing the music, indicating

that it was time for them to go on stage. I felt my nerves growing as I watched, but Bridget danced three soft shoe dances and did a perfect job. The judge, an older woman with glasses, sat straight up in her chair as she watched Bridget dance. I hoped that was a good thing. We found our way to the results board and sat there for what seemed like a very long time, waiting for the results to be posted.

Finally! The Results!! We watched the girl write the numbers on the board. #533- First place! #533- First place!! Then again, #533-First place! She won all three competitions! We jumped up and down! It was so exciting! Bridget collected three little trophies and hugged them close to her. "I love Feis," she said. We gathered up our stuff and headed to the minivan. I was shaking with excitement. That was fun. I could still hear the Irish music in my head. When we got to the van, I couldn't find my keys. I looked in the van and there they were, in the ignition! I was so nervous, I had locked them in the van when we got there. I looked over to Bridget who was still hugging her three little trophies. She looked up at me and asked, "When's the next Feis, Mom?"

CHAPTER **5**

Transfers are Awkward!

I WAS READING the town paper with a cup of Barry's Tea in my hand, enjoying a scone from the local bakery when an ad for a new Irish Dance school caught my attention. Not only was the studio right here in our town, it was actually walking distance from our home. I really hated the rush-hour ride to Bridget's classes. It was only a few miles, but everyone was on the road after school and the drive took forever. I thought the new studio might be worth looking into, even though we loved Ms. Deidre and her school.

I didn't want to mention the new school to Bridget without doing a little research first. I called the new teacher and made an appointment to meet with her on Thursday. I was told to bring Bridget's shoes so she could see Bridget dance. She also said Bridget was welcome to dance with the class during our visit. When I told Bridget we were going to see a new school, I was surprised that she didn't mind at all.

The studio was in a Knight's of Columbus Hall--nice and big but no mirrors. The teacher, Ms. Kelly, was a young, pretty woman. She greeted us with a smile. There were a few folding chairs along the side wall. We sat down and

watched the class. There were about ten girls, all different ages and sizes, lined up doing warm-up exercises. Ms. Kelly asked Bridget if she wanted to join in, but Bridget just wanted to watch. Forty-five minutes later, class ended, the room cleared, and Ms. Kelly came over to us. She asked Bridget to do a few steps for her. Bridget was shy and did not do her best, but Ms. Kelly said she saw that Bridget had natural talent and she would love to have her as a student. She explained that there would be a suspension period during which Bridget would not be able to compete. It would be a time for Bridget to learn the new school's steps and style. I was to let Ms. Kelly know our decision as soon as possible so she could put the paperwork in.

I didn't give Bridget a choice in the matter. I told her when September came along she would start to dance with Ms. Kelly. I explained that the change was only because of the traffic on the way to Ms. Deirdre's school. Bridget said she liked Ms. Kelly, and to my surprise, she asked if she could go to class two days a week. I said yes, we would be saving money on gas, so why not?

I really didn't know how the transfer might affect how Ms. Deirdre would feel about Bridget and myself. As the summer went by, I decided to just not sign up for the fall classes at Ms. Deirdre's school, thinking no one would miss us. Wrong. After a few calls from them, I finally broke the news. As Bridget settled into the new school in September, everything was going along beautifully. She loved going to class twice a week.

One day, we were shopping in the town center near Ms. Deirdre's studio, and I was looking at clothing on a circular rack. Across the way, I spotted Ms. Deirdre! *Ugh,* I thought, *this will be awkward. Maybe she won't see me.* But she saw me right away and said hello. Out of the corner of my eye, I

saw Bridget duck quickly under the clothes and hide in the middle of the rack. I was surprised that she didn't want Ms. Deirdre to see her. Ms. Deirdre said she missed Bridget, but when I explained why we left, she understood. Just as we were saying goodbye, Ms. Deirdre peeked into the middle of the clothes rack and said sweetly, "I see you in there Bridget." Then she turned and left. I peeked in and saw Bridget sitting with her knees up to her chest, those big blue eyes frozen and afraid to move. She whispered, "Is she gone?" That was the day we learned that transfers are awkward.

The Saint Patrick's Day Parade

TIME FLEW BY, and before we knew it, we were both signed up to march in the local Saint Patrick's Day Parade. Bridget was dressed in her new plaid skirt topped with a cozy Aran Sweater and hat. Of course, it had to be the coldest day of the year--beautiful blue skies but with a stiff cold wind and temperatures only in the twenties. We huddled close to stay warm. I spotted a mom and dad who seemed too happy. I found out later that they had a six pack of beer and a bottle of vodka in the baby carriage they were pushing! Bridget had the honor of holding the school banner. She held on tightly the whole way, never complaining. Our group marched be-hind the tallest and most handsome group of bag pipers. I may have been trying to peek under their kilts along the way. After the parade, the school dancers were invited to dance in front of the local Irish shop where we got our soft shoes and poodle socks. They would line up and dance one by one for hours in the cold. A great crowd gathered to watch them. Hot cocoa was served by the shop, but I made friends with the mom and dad with the booze and sipped vodka to stay warm.

The Little Leprechaun and The Feis Fights

THE SUSPENSION YEAR went by very quickly. Bridget was always ready on Tuesdays and Thursdays for class without any coaxing from me. She learned to dance in "hard shoes" and was ready for her first competition with the new school. Ms. Kelly thought it was time for Bridget to get a solo dress. We found a second-hand dress for her to wear. It was a big deal to move up from the white shirt and plaid skirt. The dress was a heavy green velvet with a lace collar and cuffs. I think it weighed more than Bridget. It had a three-panel skirt, and each panel was embroidered with beautiful swans and Celtic knots in pinks and gold. I bought a Tara brooch to hold the pink satin sash on across the back.

The night before the Feis, we spent an hour putting curlers in Bridget's hair with Dippity-doo. We used at least fifty curlers. The next morning, I had a heck of a time taking those curlers out. It was the first time we had any crying when it came to dance. With every curler that I took out, I got a screech or an "ouch that hurt!" and sometimes even tears. As time went on,

we learned it was part of our "Feis Fights" that became common before and or during every Feis, usually fueled by some sort of pre-Feis stress.

Boy, Bridget had some head of curls when I was done taking out those curlers! The dress was big and it hung heavy on her shoulders. The head of curls was out of control and the Big Barrel Headband made her ears stick out- just like a Leprechaun. She was so proud. Her confidence was beaming as she danced. She came home with her arms full of trophies again.

CHAPTER 8

The First Oireachtas

BRIDGET MOVED QUICKLY through the beginner grades and it was almost time to move up to Preliminary Championships. Ms. Kelly told me it was time for her to go to the Oireachtas in November. The "What-tac-tas?" I asked. She explained that the Oireachtas was the Regional Championships. It took a lot of practice to learn that word. O I reach for the stars was a helpful way to remember.

It was Thanksgiving weekend when we left for Philadelphia. With her Little Leprechaun Dress, a bag of curlers, and a jar of Dippity-do hair gel, Bridget was ready for The First Oireachtas! She had been practicing every day. We had no idea what to expect. When we arrived, we entered a beautiful hotel. The ballroom was huge with a large elevated stage, nothing like the boards on the floor we were used to at a Feis. We had our traditional "Feis Fight" in the room while taking the curlers out. After we put Bridget in the Leprechaun dress and her shoes, Ms. Kelly gave her a little inspection and we pinned on her number card.

It was time for her to line up. There were more than one hundred dancers in the competition. We noticed that a lot

of the dancers were in brand new neon-colored dresses, far from the traditional "Leprechaun look" Bridget had. Bridget looked nervous. As her turn was approaching, I noticed her nervously yawning. I could see her watching—no, studying--the dancers before her, looking more anxious as time went on. Finally, when it was her turn, she walked quickly up on stage. The music started- and she froze! She looked like a deer in the headlights, like her shoes were glued to the floor! She had a false start then danced way off time. When the music stopped, she got off the stage as fast as she could. As Ms. Kelly and I got her out of her dress, Bridget calmly said, "I think I need a new neon dress made just for me, and I will do better next time." Ms. Kelly and I just looked at each other. Then Bridget sat in her chair and watched the rest of her competition very carefully.

The First Solo Dress—
The Most Beautiful Dress Ever!

NO ONE EVER brought up the disaster at the Oireachtas. It was February and we were all home on a snow day. Ms. Kelly called me and asked to meet in town at the diner to discuss ordering a new dress to be made in Ireland for Bridget. I had already received some color swatches from the dressmaker and had been secretly waiting for Ms. Kelly to give the go-ahead for a new dress. When I told Bridget, she was so excited. She told me she had a vision of what she wanted. She filled me in with the details on our walk in the snow.

We sat around the table at the diner, barely noticing how heavily the snow was coming down outside. We had fabric swatches all over the table amongst the pancakes and cups of tea. We chose a neon pink dress with aqua blue glitter dot and neon yellow sparkle stretch fabric designs. The sleeves would be silver glitter dot. It was going to be "The Most Beautiful Dress Ever," Bridget announced. We sat there for hours, and when we exited the diner, we were greeted by a full-blown blizzard. As we hurried home, Bridget talked the

whole way about her neon dress.

It took months to have the dress made, so Bridget did a few more Feis in the Leprechaun dress. Her first Preliminary Competition was at a Feis an hour and a half away. All dressed and ready to line up, she saw the judges--three of them--sitting in front of the stage. Curious, Bridget walked right up to one of them and looked over his shoulder to see what he was writing! Ms. Kelly couldn't think quickly enough to stop her. The judge snapped at her, "You can't be over here--don't EVER approach a judge!" She jumped back, stunned, holding in tears. We rushed her over to the line. I said to the attendant, "This is Bridget's first Prelim competition." She said back to me a bit snarky, "OH, this isn't the Feis to have as your first prelim- there are 78 good dancers here today." She was right; it was a tough competition. Bridget placed 57. She took it in stride and knew she had a lot of work to do ahead of her.

One day in June, a big box arrived from Ireland. I called Ms. Kelly over so we could open the box together. She brought a few dance moms and dancers from our school. Bridget was so excited. We all stood around the box on the floor. I opened the box and I could see the pink and yellow peeking out at me under layers of tissue and plastic. After pulling the layers away, there it was--The Most Beautiful Dress Ever! I lifted the amazing work of art out of the box to a chorus of oohs and ahhs. As we carefully slipped it onto Bridget, we stepped back and took a good look. It fit perfectly; it was just the right length with no room to grow. Then I looked down into the box and saw the bill-1,246 US dollars! Now I understood what Ms. Deidre meant when she said she hoped I had a lot of money!

The Circus Dress

THE MOST BEAUTIFUL Dress Ever only lasted six months. It was worn for the first time in June at a Feis and the last time at the Oireachtas in November. Bridget was right--she did have more confidence in her new neon dress. She proved herself worthy with a lot of hard work and placing well at the Oireachtas. "Job well done, Bridget," Ms. Kelly said, "because you grew so fast, we need to sell this dress and order a new one right away." Bridget smiled at me and said "Momma you can design this one--I need to practice more so I can get into Open Championships."

By now, I had become a full-fledged Feis Mom. I heard someone refer to it as a M.A.I.D. Mother Addicted to Irish Dance. I would take her to class three days a week (she practiced at home too) and take her one day a week to the YMCA for a strength training class. I kept up with the current trends, signed her up for her Feis, packed up her gear, drove near and far to competitions and dance-outs, unpacked her gear, polished her shoes, repacked, and did it all again. My favorite new trend was the curly wig. After I spent years putting in curlers, someone came up with the idea of a wig. *What a*

great idea! I thought. *What took so long?* I hoped this meant the end of our "Feis Fights." At the next Feis, we went to a vendor specializing in wigs and bought a light brown, shoulder-length wig with tight Shirley Temple curls.

With a new batch of swatches from the dressmaker, I sat with a cup of tea, trying to design the new dress. I picked a pretty, dark blue raw silk for the bodice with pink, silver, and yellow neon for the designs. Celtic knots and animals were not so trendy anymore; bold blocks and swirls were in. I didn't have the help that I had in the diner, so I left the design up to the dressmaker. Excitedly, I mailed the packet of color swatches and measurements off to Ireland.

The dress arrived a lot quicker this time. I was able to sell The Most Beautiful Dress Ever to a dancer in our school for $1,100. *Perfect,* I thought, *it would cover the cost of the new dress.* When the box came from Ireland, I waited for Bridget to get home from school to open it. There was no audience this time, just the two of us. I didn't know what to expect. As I cut the tape on the box, my hands shook. I pulled the layers of tissue off and I saw the colors I picked, but in a strange pattern. It reminded me of something that I just couldn't put my finger on. I held it up and suddenly it clicked—it was A CIRCUS DRESS! IT WAS SO UGLY! I didn't say a word, but panic set in. What the heck kind of a design was this! The bodice was the pretty blue I had picked, and it had silver glitter dot sleeves, but the design in the bodice and along the skirt and sleeves was too much. There were blocks and triangles all over. UGLY! The Circus dress had come to town!

Bridget thought it was beautiful. She loved it. It fit better than the first one and at least there was room to grow (I had secretly added a few inches to the measurements just to be safe), but it backfired on me--it was too long. While Bridget

looked at herself in the mirror and danced around happily, I looked in the box to find the bill. I found it--1,456 US Dollars for an ugly circus dress. Yikes!!

The funny thing was, the circus dress looked great on stage. I added a few crystals here and there and I would squint my eyes when she was up there dancing and it looked better. She was growing so quickly, so in a few months, the length would be perfect. Feeling confident about Prelim and the new dress, Bridget convinced us to travel to a Feis almost every weekend. While we were heading to a Feis in Connecticut, Bridget was excitedly talking the whole way, taking notes of where we were. Once we got there, we set up camp in a corner of a hall. We laid a blanket on the floor, our folding chairs perfectly placed, and waited for her competition to start. It got really crowded. We had to stand on chairs on the back side wall of the ballroom just to watch her. We thought Bridget danced two perfect rounds and she was also pleased with her dancing. We waited a few hours for results. Bridget made the time go faster by fluttering around, socializing with everyone she knew. When it was finally time for the results to be announced, we all gathered around. We were way in the back and couldn't see a thing. Usually, the announcer would call the placers up, then start from the bottom up to first. This time they just started with 18th place... so we didn't know if she placed or not. They announced all the way down to fifth place and we started to get nervous. 4th, 3rd, and 2nd were called--nothing. *Oh well,* I thought, *it wasn't so good after all.* Just when I was preparing to console Bridget, they called the winner- #157! It was Bridget! She looked stunned for a second then ran up to the podium. She carefully climbed to the top and was handed a beautiful crystal vase. She stood proud beaming from ear

to ear. She spied her dad and me in the crowd, and tears of happiness filled her eyes. First place in Prelim! So exciting! I was shaking. Her dad was hooting and hollering. We took a few pictures and everyone bowed. She stayed on the podium for a long time until the Feis volunteer told her to get down so they could start announcing the next results.

We were so proud of her first place win in the circus dress, we went over to the professional photographer and had her picture taken with her piece of crystal. We finally packed up the van and were ready to head home. Once on the highway, full of the excitement of the big win, the three of us were chatting away about the day's events. Suddenly after about a half an hour Bridget said "It doesn't look right-why are the numbers on the highway going up? They should be going down if we are going home." Confused, her dad and I looked around and sure enough we were going north instead of south on the highway.

The Prelim Push (to Open)

THAT FIRST PLACE in Prelim was the beginning of a wonderful and well-deserved chain of events for Bridget. She got first place the next weekend in Pennsylvania then another the next month in New York. Because we were nuts, we signed up for a double-Feis weekend, and Bridget won both of them. Ms. Kelly thought it was time for Bridget to compete at Nationals for the first time. It would be in Boston in July, so we decided to make it a family vacation. She placed well and brought home another piece of crystal. By now, I was loving the Circus Dress. It stood out on stage like no other dress. It fit perfectly. Bridget's growth spurt winded down, so we didn't have to think about a new dress for a while. I had heard that it was good to stay in a dress as long as you could so the judges get to know you.

Bridget was doing so well that Ms. Kelly set up a surprise for her. Trinity Irish Dance Company was coming to a theater in our area and they had asked some of the local schools to pick their best dancers to perform on stage with the company. Bridget was so excited to be picked. We gathered a few family members and all went to the show. It was phenomenal! In

between a few numbers, Bridget and the other dancers got their moment on stage. Bridget looked like she was having a ball. At the end, the dance troupe held hands with the little dancers and proudly introduced each one of them. We were so delighted to hear Bridget's name. After the show, there was a meet and greet with the cast. She got a few pictures and autographs. Her grandma gave her a bouquet of flowers. At the gift shop, Bridget bought a Trinity poster to put on the wall next to her Riverdance poster.

Bridget did a lot more Feis over the year and won a total of twelve first place trophies!! By late fall, we learned about "The Prelim Push." Other dancers and their moms didn't like when a dancer kept winning firsts in Prelim without moving up to Open. Some of Bridget's best friends didn't like her anymore. Some gave her the cold shoulder. After a win, instead of congratulating her, the girls would ask her if she was doing the next Feis. One stomped away with her mom close by after Bridget innocently replied, "yes." Bridget felt badly, but she told me she wasn't ready to move up because she had "a lot more practice to do" and Ms. Kelly agreed.

Open and The Ice Princess

BRIDGET WAS VERY nervous about moving up to Open. None of her friends had moved up yet, and Bridget was worried that she would miss them. I knew for sure that some of them were glad to see her go. It was time to order a new dress for Open. *It should be extra special*, I thought to myself as I pored over a new batch of fabric swatches. I wondered if anyone had ever made a dress completely of sequined fabric. I found a gorgeous mother-of-pearl heavy sequined swatch. In the light, it picked up all different colors. I picked hot pink, purple, light blue, and gold to go with it. I asked for a hot pink under the skirt and for purple polka dots to be embroidered. I was told that it would cost me a lot more than I was used to. If I sold the Circus Dress for $1,200, maybe it wouldn't be too much more.

The first few Feis in Open did not go so well. As we waited for the new dress, the Circus Dress looked tired and worn. Along with Bridget not feeling very confident, she did not place in the first few competitions. She was frustrated, but she was a good sport about it. She was a graceful loser--she would be happy for her new friends and would make sure to

congratulate them. She would visit her friends who were still in Prelim and would wish them good luck. She would learn to sit and watch her whole Open competition to see what steps and sets the other dancers were doing.

Finally, the new dress had arrived. Bridget was at school, and this time I decided to open it alone. The box felt a lot heavier than the others. I didn't even look for a pair of scissors; I just grabbed a knife from the kitchen. Carefully, I slid the knife along the box to open the tape. First I saw the new red plaid dress bag that I had ordered. It was very wide so the panels of the skirt wouldn't get damaged. As I opened the layers of tissue and plastic, I felt like I was like looking into a treasure box of gold and diamonds glittering in the sun. I unfolded the dress and laid it flat, and a beam of sunshine blasted rainbows all over the room. I expected to hear the angels sound their trumpets; it was truly a dress for a princess--an Ice Princess. I was so excited about the dress that I totally forgot to look for the bill. Later, after showing Bridget and her friends, I noticed it in the box. 2,127 US Dollars!!!! Oops! $$$

The Ice Princess would make its debut at the Nationals. The colors were light, so Ms. Kelly and I decided to get a new, longer-style wig in platinum blonde. Bridget was older now, so we added heavy makeup and spray tans to our list of rituals. She had been wearing triangular traditional shoe buckles, but I had an idea to liven them up--I would cover them with Swarovski crystals, clear on the outer edge and pink on the inside to match her dress. I would call them "The Original Lucky Buckles." No one had ever seen them before. They were blinding. The whole look was amazing. She looked like a princess from head to toe. Ready to go side stage, she put a final roll of sock glue on her socks,

took a sip of water, put some lip gloss on, and turned to me and said, "Don't worry Ma–I will do well!" And with a giant smile on her face, she bent over and flashed her pink and purple polka dot underskirt at me! We both laughed. The Ice Princess danced amazingly, placing 11th and qualifying for the World's for the first time.

Feis Dad and The Man Bag

NOT EVERYONE'S DAD was as involved as Bridget's was when it came to dance. He would drop off and pick up Bridget from class at least once a week. He would make sure to get out of the car and greet the dancers at the door. He would ask them how they were and how they did at the latest Feis. He would wander the Feis to find dancers he knew to wish them good luck and watch them dance. He would be at their awards to cheer them on. They were always excited to see him.

At one Feis in the summer, we packed up the new Durango with as many dancers and their moms as we could fit, and headed to the Rockland County Feis in the Bear Mountains of New York. It had rained for days before, and we all sank in the mud as we set up camp for the day. We had a tent, folding chairs, tons of food and beer. As the dancers socialized and prepared for the Feis, we moms and Feis Dad gathered around a nice fire pit in the field and chatted away. We drank a lot and found out it was a long walk up the hill to the restrooms. There were great vendors and bag pipers piping away on the side of the mountain and other Irish games going on in the fields. Suddenly, the heat of the day turned the sky black

and it poured buckets on us. As we raced to get under the tent or in the Durango, Bridget got soaked and very upset. She started crying when a bolt of lightning hit the ground near us. When it passed a few minutes later, everything was a muddy mess. We all laughed and cleaned up the best we could.

We waited to hear if the Feis would resume. Soon, the sun came out, and the heat of the day made a curtain of steam all around us. It was announced that the dancers did not have to wear their costumes, only shorts and a tee shirt. When it was Bridget's turn to dance, she was just awful. She placed last.

The adults tried to keep the day moving along. It was time to cook burgers and hot dogs. As we set up the food, Feis Dad got the portable grill ready, and as he lit the flame, the grill blew up sky-high to the tops of the trees! There was a loud bang and a flame so high, the treetops were singed! Holy crap! We all ran for the hills. He was able to control the flame that was dangerously close to the Durango. We were all very lucky. As we came down from the hill, I heard someone screaming. A large snake slithered in the wet grass right in front of us. As we caught our breaths and settled back down in our wet chairs, the sun came out again. We cooked our hot dogs on sticks in the soggy fire pit, laughing about the day's events.

The next Feis that summer, Feis Dad had a big surprise for us. He had bought an old limousine. It was black, and he had large green shamrocks painted all over it with a sign that said "Feis Mobile." The inside was fully stocked, disco ball and all. With his Irish cap on his head, he picked up all his favorite dancers and their moms and drove us to the Feis. It was a sight to be seen when we pulled up to the Feis and all piled out! When Bridget's results took forever, he retreated to the Feis Mobile for a nap. Sadly, the Feis Mobile only made it

to that one Feis--the transmission went and it was too old to fix. It retired to the junkyard.

As we traveled to each Feis, the amount of stuff we had to bring kept multiplying. Folding chairs, blankets, the dress bag, the shoe bag, the wig box, the makeup bag, the food and drink bag, and the "Man Bag." The Man Bag was black leather with nice sturdy straps. Everything else went in it. It was always stuffed with last-minute items--the camera, sock glue, bobby pins, an extra headband, glue scissors, safety pins, ice pack, lip gloss, icy hot, tissues, twizzlers, pixie sticks, you name it, and it was in the Man Bag. After folding chairs and organizing everything to leave the final Feis of the summer, I handed Feis Dad the Man Bag. He made a face as he handed it back to me and refused to carry it. He said it reminded him of the Man Bag Joey carried in an episode of Friends, and he wouldn't be seen carrying it. He would rather carry the pink polka dot dress bag than that Man Bag!

CHAPTER **14**

The Missing Points in The Bathtub

ANOTHER OIREACHTAS SEASON was upon us. Bridget was feeling confident about her dancing. The Ice Princess dress was fitting her perfectly now that she had grown a few inches. She had a new, even longer curly wig and new makeup. She looked great. All three rounds were clean and sharp. She didn't "die"--she was worried about her stamina, but going to the gym and jogging regularly paid off. We all thought she would be in a qualifying spot for Worlds. The result proved otherwise. Out of 67 recalls she placed 27th. We were all shocked. There was no explanation. She ran to the bathroom from straight off the stage after hearing the results. She tried to control the tears in her eyes so no one would see. I ran behind her and once we were in the bathroom, she turned to me and as she looked deeply in my eyes, she blurted out, "They HATE me MOM." At that moment, one I will never forget, I didn't know what to say. My own eyes filled with tears and all I could do was hold her tightly.

I knew something wasn't right. Ms. Kelly said it could be as simple as the judges not liking her style. Trying to distract Bridget from the whole thing, we went out to eat and settled

into our room early that night. As I laid in bed, I couldn't stop thinking about the results. It didn't seem right. Finally around midnight, I got out of bed, took a blanket and the result sheets, and sat in the bathroom so I wouldn't wake the family. I reviewed the scores over and over, trying to make sense of them. Finally hours later, I figured it out. It was there right in front of me the whole time. Her converted Irish points were not on the sheet. The raw scores were high and they were supposed to be converted to Irish points. It said "0" in all the spots! And it looked like a few dancers around her were missing them too. (If I tried to explain the Irish Point system I would have to write another book!) I knew it! I finally fell asleep early in the morning in the bathtub! That's where the family found me clutching the score sheets in my hand.

CHAPTER **15**

The Sweetheart Dress

LIFE SEEMED TO evolve around dance. We were going to at least one Feis a month. All-Irelands. Nationals. Worlds. With no letting up. Family vacations were planned around dance. The Ice Princess was starting to look a little outdated, so it was time again for a new dress. This time, Ms. Kelly said we should use the most sought-after dress maker in Ireland. She took measurements and sent them off with a picture of Bridget. We were told to leave the design and colors to them and they would make a current-style dress custom-made for her. I was a little uncomfortable with this but we had no choice--this is how it works with this famous dressmaker.

There was no gathering around to open the box with the new dress this time. It never came! Expecting it for the Oireachtas in November, we started calling in September. No response. In October, Ms. Kelly tried and there was still no answer. We heard the dressmaker was coming to do fittings for another school, and Bridget's should be in that group. Nope. A week before the Oireachtas we were told it would be delivered at the "O." (Make me nervous!). Bridget was asking me

every five minutes about the dress!

Finally, the night before Bridget danced, we got the call. We went to a room in the hotel and in the corner on the floor was a pile of at least twenty dresses, each one in plastic. We had to look at each dress to find her name. When we finally found Bridget's dress, I was immediately concerned. It was tiny. It couldn't be hers. Bridget snatched it from my hands, peeled it out of the plastic and held it up. She smiled and screeched--it was beautiful. It was mostly white raw silk with magenta bold triangles and arrow shapes in it. The bodice was magenta velvet with a pretty sweetheart neckline. It had a new-style five panel skirt with magenta sequin fabric peeking out between each panel. As Bridget stepped into it, it was obvious it didn't fit. It was way too short and it barely zipped up. But Bridget loved it, so Ms. Kelly and I decided to let her wear it anyway. We had sold the Ice Princess and were having trouble finding a loaner dress.

The next morning when Bridget walked on stage in the new "Sweetheart Dress," her Dad and I were both amazed by how grown up she looked. Our little dancer wasn't so little anymore.

After a few alterations, including adding a row of lace along the bottom of the skirt, the dress grew on us. Everyone remarked how lovely she looked. The dress complimented her elegant dancing style. She placed well in it. At the next Feis in the spring, someone pulled me aside and told me to watch for Fiona in her new dress. She copied Bridget's dress! I couldn't believe it! Same colors! Exact same style! Then I remembered Fiona and her mom talking to Bridget at the Oireachtas complimenting her in her dress and asking a bunch of questions about it. I thought it was odd at the time. We could not believe

someone in the same competition would copy a dress. When they stood next to each other during results, they looked like twins. Shame! Shame! By the time the Nationals came along, Fiona was in a completely different dress.

CHAPTER **16**

The Wonder Years

BRIDGET HAD NOW graduated high school, and I saw no signs of letting up at all with Irish Dance. She was helping Ms. Kelly as an assistant teacher and had started studying for her T.C.R.G. (Irish Dance Teacher Certificate). She still dreamed of being in an Irish Dance Show, but not until she finished college. Her college of choice was only an hour away from home and a half an hour to one of her school's studios. There were other Irish dancers in the college, so they practiced and worked out together all the time.

During her first year in college, all her hard work paid off with high placements at Nationals, Great Britain's, and Worlds. She had another new dress in black and gold with thousands of crystals on it. At the Oireachtas, the stars seemed to be aligned perfectly. Everything went well. She had three clean rounds, and the judges were known to be fair. There was talk that she could win the competition. With each compliment, she just smiled, said "Thank You," and tried not to think about it. For good luck, Sonia, Bridget's sister and biggest fan, gave her a beautiful gold necklace with the word "Believe" on it. Bridget put it on right before results.

I was so anxious about the results, I had to have a few cocktails just to calm down. I felt sorry for Feis Dad and Sonia sitting on either side of me. As they started calling out the top ten, my nails were digging into their thighs. My heart was pounding so loudly, I could hardly hear the numbers being called. She was in the top ten! They were down to the top three and Bridget was still up there.....Then it all went in slow motion. In a flash, they called her name--second place--I had never been so happy and so let down at the same time for anything in my life! She was beaming brightly up there on the podium. It WAS a great accomplishment! Later, we had a gathering in our suite with champagne and loads of food to celebrate.

After many changes of clothes, and her sash proudly displayed across her dress, Bridget and her friends headed off to the lobby to continue the celebration. Her dad and I were too exhausted to join the festivities. The next thing I knew, it was 4 am, and I heard Bridget making a racket as she came in the room. Relieved that she had safely returned, it was still dark out so I went back to sleep for a while. I awoke at 7 am to a room brightened by the early morning sun. The first thing I saw was Bridget on the pull-out bed with blankets and pillows scattered all over, hair a mess, sound asleep still in her dress, with her second place sash still on her shoulder. After I took a few pictures, I pulled a blanket over her and tucked her in. At that moment, I wondered how much longer this wonderful adventure in Irish Dance would continue.

Senior Ladies and Bling is In

BRIDGET WAS NOW a Senior Lady and a senior in college. We decided to order one last dress, this time from a local dressmaker. It needed to be amazing. It took six months for us come up with the design--large Celtic knots in the bodice and on the sleeves in an ombre of pink, a four inch collar completely encrusted in stones, and a short black ballerina tutu skirt with no stones to balance out the heavily-stoned top. We secretly disguised a "B" for Bridget into the design on the bodice. It was truly a work of art. The stones alone cost more than the complete cost of "The Most Beautiful Dress Ever." I won't ever tell anyone how much this dress was. Feis Dad will never know!

The first time Bridget wore this beauty was at a Feis. We decided to follow a new trend and top it with a "Bun Wig." A new large stone tiara in place, new poodle socks covered in stones, AND new crystal Lucky Buckles with sparkly pink glitter soft shoes for awards, Bridget was ready to go. While her competition was lining up, we took one last look to make sure everything was perfect. She gave me a kiss, and as she turned to go, I saw that I forgot the sash! I looked in the dress bag--no

sash. I had left it home on the kitchen table! Panicking, I had to think fast. I told her to get in line and I ran around the vendors, looking for something to use. Luckily, I found a large black silk flower pin about 3-4 inches wide. I explained to the vendor what I needed it for and I ran over to the line. I pinned it to the back of the dress and it looked like it was made to be there. It's still there--the perfect feminine touch.

The Last Nationals: Today is Your Day

BRIDGET WAS FEELING confident in the morning leading up to what has been called "The Last Nationals." Ms. Kelly and her other teachers all said Bridget had been dancing beautifully. She danced two perfect rounds and her new set, named the Vanishing Lake, was awesome. Sometimes you just know when everything is right. The rotating panel of judges was always better for Bridget than the "fixed" panel, since she would have a fresh set of eyes every round. And she wasn't first in the rotation like the last few majors. She just had that luck. Being first up was considered unlucky, as the judges would hold back their higher scores to see if they should give those scores to dancers later on in the competition. That practice was confirmed at a Feis once, when a judge called Bridget over after results and apologized for not giving her higher scores, explaining that it was because she was first up. He added that she had danced beautifully and that she had deserved higher placement.

When they called up the top ten--Bridget was in it! She

jumped up and down and ran over to get in the lineup. She looked to her sides and saw that she was among the best of the best. Feis Dad had to stay home this time and I needed something to calm my nerves. I reached into the dress bag pocket where Bridget kept her collection of lucky charms she had collected through the years. I found a sea shell that her sister had given her that was inscribed with the words, "Today is Your Day." Perfect! It fit perfectly in the palm of my hand and I ran over to the front and center of the stage, clutching it. I could see she was still looking off to the side where I previously stood. I jumped up and down as they called 10-9-8-, the shell sweating in my hand. They called her name- 7th place!! I screamed out loudly so she could find me. I never saw her look so proud, 7th place amongst the best of the best!

The Last Feis

SURPRISINGLY, INSTEAD OF reducing the number of Feis she attended, Bridget wanted to compete more. But it was getting awkward dancing with eighteen year olds. At one Feis, a teacher from another school said to Bridget that she was "too old to Feis." Bridget just smiled at her and won first place that day. Through the years, the faces had changed, but there were still plenty of familiar ones. There was a much larger group of senior ladies still dancing. When Bridget was little, a Senior Lady competition would have 3 or 4 competitors in it. Today there are usually 20-30 dancers.

At Bridget's last Feis, I was feeling a little sad. I was still wondering why we continued this for all these years. Then I saw Bridget stage side looking amazing, sparkling from head to toe, talking to her friends, smiling, yawning nervously, and practicing on her fingers while she waited. When it was her turn, she gracefully and confidently walked on stage to that spot she has walked to what seems like a million times, arms to her side, toe pointed, shoulders back. She waited for the music to start. At the right moment, she glided across the stage, graceful, but powerful and strong. She had complete

control of her whole body with each and every step, a smile on her face up to the end. I don't think I breathed a single breath while I watched her dance that day. It was then that I realized there was nothing to wonder about--it was all a blessing to have spent all this time together as a family. We had a passion for something not everyone will understand. I am so glad Molly and her mom walked by all those years ago, who knew? Did you ever wonder what your life would be like if that one thing didn't happen? We would have missed all of this.

As Bridget bowed her last bow to the musician at that Last Feis, the tears rolled down my cheeks. But I pulled myself together by the time she came over to me and I let her know what a wonderful job she did. We high fived and did the same old routine of packing up the gear and moving to the results area where we sat for hours, waiting one last time for the results.

The Final "O"

FOR THIRTEEN YEARS, we would have Thanksgiving dinner early with our family and race down to Philadelphia to settle in at the Oireachtas. Feeling a little sad about it being the last one (so Bridget said), I prayed that everything would go well. As we were packing up the car to leave, Bridget's older brother said, "I thought last year was your last one?" and "When are you going to stop all this dance nonsense? You know it's all political. " My turkey dinner churned in my stomach. Bridget just gave him a hug and got in the car without a word.

It was very early Friday morning and Bridget had an appointment to have her wig and makeup done by her favorite vendor. She usually did it herself, so this was a treat. She looked really pretty. We got our seats and she went to warm up as we prepared for the day. Then, everything started to fall apart. She was first up in the first round and she got a judge who didn't like her style. *We might as well just leave now*, I thought to myself. She got herself ready and didn't let any of it bother her. She gave it her all, and everyone said how great she danced. Ms. Kelly and her other teachers prayed for top five. But it wasn't to be. At results, she was proud and happy

to be standing next to her friend Kathleen with whom she has danced since they were twelve years old. It didn't matter how she placed, what mattered is that she was there and she loved every moment. We opened up some champagne right there in the ballroom, and toasted with plastic cups to a great "Last Oireachtas" with everyone around us. We were the last ones to leave the ballroom, escorted by security.

When we got back to our room, there was a surprise for Bridget. There was champagne in a silver bucket on the desk, along with a platter of chocolate-covered strawberries and a bouquet of flowers. There was a note from Bridget's brother and sister-in-law that said "We are so proud of your hard work and dedication to Irish Dance. We love you!"

CHAPTER **21**

The Show and the Future

SHORTLY AFTER THE last Oireachtas Bridget thought it was time to put a dance resume and audition tape together and send them off to some Irish dance shows. She was asked to join a show called Rhythm in the Night. They would travel the United States over a two month period. She was so happy. She signed a contract with them and gave a leave of absence at her job. For the next two weeks, she studied the seventeen segments of the show via the internet. She practiced every spare minute she had. And she thought she practiced hard for a Feis! Suddenly it was time to go--she was off to live her dream, to dance in an Irish dance show! Feis Dad and I couldn't be happier for her.

Her days were long and exhausting, and we would go weeks hardly hearing from her. The show was coming to a theater nearby, so naturally we told everyone we knew. I bet we filled up half of the theater. I was so excited. Feis Dad was worried about me; I could hardly breathe. Once I saw her on stage, Feis Dad and I held hands tightly. Each time she came out on stage in a beautiful costume and danced perfectly and professionally, I thought I would explode from the excitement.

I felt like one of those Feis Moms who danced along with her dancer's routine during a competition.

When it was over, they got two standing ovations. Shaking from the excitement, my knees weak, I found my way to the back of the theater. Deep in the crowd, I finally saw Bridget in a sparkly red sequin dress, hair long and curly with a crystal tiara, looking beautiful with that familiar big smile, holding a bouquet of flowers. All around her were the dancers from her school and she was signing autographs and taking pictures with them. She looked up and saw me, ran over and gave me the biggest hug and said, "Did I make you cry Momma?"

I still haven't stopped talking about the "Show." It had been weeks and she was still touring. She loved the people she was working with. She said she could do this forever. Soon the tour would be over and I thought it would be the end of Irish Dance for us. But one day, I got an actual call from Bridget, not the usual quick text. I heard excitement in her voice. She said "Ma, book the flight for London-I've decided to go to Worlds after all!"

J'aime Montreal and It Must Have Been The Pierogies

AFTER WORLDS, BRIDGET decided to surprise us and go to Nationals in Montreal. I didn't even try to influence her to go, but I had hoped that she would want to. Although, I must confess that I did buy the Montreal mug to add to my Starbucks City Mugs Collection. I had one from every Nationals we went to and one from every Worlds. I showed the mug to Bridget when I got it last summer; she just smiled, ignoring me. I kept it in the box until we were sure she was going. It is now added to the collection on a shelf in the kitchen.

It was late when we sent in the entry fee. There was a new excitement in the air. Bridget was practicing every day, on a strict diet, jumping rope, and running a few miles a day. We called the dressmaker, thinking a new dress would be the next thing to do. She was willing to squeeze us in, but after a few failed attempts to get together, we lost too much time. Her current dress was so beautiful and fit perfectly, so we ended up happy we didn't rush into a new one.

Before we knew it, we were packing our bags for Montreal.

Bridget left a few days earlier with her friend Katie from the show. She settled into our room and practiced, of course. Then she headed to the vendors to get the all-important program, new soft shoes, new crystal socks and more white tape. I was in the car halfway to Montreal with Sonia and Cousin Amanda coming along for support, eager to see the lovely sights of Montreal, when I got a series of texts. They were excited texts from Bridget with pictures of the pages of competitors in Senior Ladies. "Not first up," one said. "Rotation good," was the next. "Steak house for dinner tonight", was the last.

At last year's Nationals in Anaheim, California, we had dinner at a great steak house the night before she danced. She had salad, filet mignon, mashed potatoes, and broccoli. It was a lucky dinner, she got 7th place. This year it had to be exactly the same. So we sat at another fabulous steak house the night before she danced, ordering salad, filet mignon, mashed potatoes, and broccoli. I told stories about the superstitions Bridget had before a competition while we waited for dinner. It had to be pasta the night before Nationals in Boston, where the runners ate pasta the night before the Boston Marathon. The night before every Feis, Bridget's Grandmother would make her pierogies for good luck. I told the story of the pierogies Grandma sent with us to the Catskill Feis one year. They were frozen solid in a zip lock bag packed in a small cooler with the other snacks for the weekend. We were staying at Gavin's Resort in a little cabin. There was no microwave in the cabin. It was a three hour ride and it was already dark when we arrived. The office and kitchen were closed. But Bridget had been thinking about those pierogies the whole ride up. So I filled up the bathroom sink with hot water (after a good scrubbing!) and floated the frozen pierogies in the bag

in the sink until they were thawed and warm enough to eat. I scooped a few dollops of sour cream in and she ate them right out of the bag. First place at the Feis! And first place at the Blackthorne Resort Dance Competition that night too. "Must have been the pierogies," became a familiar phrase.

Bridget would never eat much the morning of a competition, only a banana and water. If she danced later in the day, a bagel might do. But most competition days consisted of "Feis Food" for all of us. The Man Bag would be filled with pixie sticks and twizzlers and chocolate to get us through the day. After the long Feis day, we would race to the first McDonald's we could find or order room service if we were at a Major.

We talked for a long time at the steak house over a delicious dinner. Bridget cleaned her plate, not leaving even a morsel behind. She announced it was time to go. The night before a Major ritual begins. After a walk around a park nearby, we headed back to the hotel. Sonia, Amanda, and I stayed in the lobby for a night cap. Bridget reminding us not to be too long. She showered, dried her hair, and tanned her legs. As we came out of the elevator she was in the hall jump roping. "What took so long?" she said. As we entered the room, I could see she had been busy. The bathroom counter had all her makeup lined up and ready for the morning. The wig, bobby pins, donut, curling iron, and hairspray were lined up in another spot. On the back of the desk chair were her workout clothes and school jacket, all in matching pink and black (to coordinate with her dress), laid out neatly. In another corner were her two pairs of socks, one with crystals and one without, sock glue, hard shoes, new Lucky Buckles, new soft shoes and shoe polish. "Could you polish my shoes Ma? Thanks." she said. Between the beds on the light table were

all her good luck charms she collected through the years and a good luck card from Sonia displayed nicely. It was a sight. I often wondered if this was normal, and what everyone else's rooms looked like.

We all knew the routine. "Get to bed everyone, I'm turning out the lights," Bridget warned us. It was almost 10:00 pm. The alarms and wake up call were set for 5:45 am. The competition started at 8 am. I was last to climb into bed a few minutes later, and Bridget was already asleep. Five forty-five came very quickly. It was hard to get up. As I slowly crawled out of bed, I gave Bridget a shake. I went to take a shower and get dressed. When I came out, Bridget was already at the desk, putting her donut on her head. I left to get tea, a banana, a bottle of water, and a red-bull in the lobby. By the time I stepped off the elevator, Bridget was in the hallway, jumping rope in full wig and makeup, all ready to go. "Time to go Ma. You ready?" she said. She wanted to be at the door of stage A at 7:00 am when it opened. Feeling rushed, but not saying a word, I gathered the man bag, the dress bag, the journal, and my tea. I asked if we forgot anything, and I was told "time to go." If we forgot anything, Sonia could bring it over later. I whispered to Sonia to text when she left in case we forgot anything. In the taxi to the Palais des Congres we went down the list and felt confident that we had everything. As we both took a deep breath, looking out the window of the taxi at the lovely city of Montreal, Bridget said "It is going to be a good day." We both smiled with the rays of the morning sunrise on our faces.

We settled into our spot in ballroom "A" front left side, first row. Bridget went to warm up. I sat and sipped my tea, still not awake. There were only a few people and it was 7:15. The room was cold and as I put my sweater on, I thought how

exciting it was to be there and how hard it was going to be for Bridget to stay in the top ten again. I was sure she could handle it if that weren't the way it would go. As I finished my tea, the room started to fill up. There were some familiar faces. I saw Kathleen and her mom. Kathleen was the one who declared "we should keep on dancing until we are 24." And there were a lot of faces I had never seen before. The girls from Bridget's dance school were there--four senior ladies in the same competition. "We can't stop- we won't stop" was the logo on their shirts.

Before we knew it, 8:00 arrived, and the competition was starting right on time. Bridget's rotation wasn't until the end, so as she stretched outside the ballroom, I sat and watched every dancer. There was one special dancer that stood out from the rest. You couldn't help but notice that she had no hair and no wig. She looked like she had some sort of illness, maybe cancer? She was so proud up on stage. She danced well. She looked strong and I hoped she would be ok. As she danced I felt emotional and I welled up with tears. Only when she was done dancing did I look around to see that I wasn't alone. There wasn't a dry eye in the hall.

Finally, it was Bridget's turn to dance her first round. It was perfect. One of her teachers said it was the best she ever saw her do her jig. I could tell she meant it. She smiled quietly and went back to watching the competition. Just before it was Bridget's turn in the soft shoe round, her friend Katie was up. She and Bridget practiced a lot together. On the ten-hour train ride up, Bridget coached her for little extra attention. All Katie dreamed of was getting a recall. Katie has always called me her "Favorite Feis Mom." Excited for her, I walked to the back of the hall to watch her dance. She had a beautiful smile on her face. As I watched, I smiled from ear

to ear, so happy for her. Then, in the blink of an eye, I felt a cold breeze around my shoulders, and Katie's eyes locked on mine. I could see she was watching me the whole time very closely, still with that big smile. My eyes welled up with tears, and I tried hard not to let it show as she continued to watch me. I felt frozen in the spot where I stood. Then a feeling came over me that was so strong that I knew instantly what was going on. Katie's mom had passed away suddenly a few years back. Katie's mom's spirit was watching her dance through my eyes! I could hardly breathe, holding in those tears. When she stopped dancing, the feeling went away, but not until she walked off stage did the tears roll down my face. I made sure to avoid her for a few minutes to gain my composure. I was shaking and I needed to sit down. I found my way back to my chair. After a few sips of water, I leaned back in my chair and thought about how emotional the day had been so far! I felt exhausted.

It was time for Bridget's soft shoe round--her time to shine! After her flawless first round, I wondered if this round could be as good. It was! Perfect! So pretty! After letting both Bridget and Katie know how great they both looked on stage, it was time to sit and wait for the recalls.

It would be a few hours, so we decided to go for lunch and wander the Underground of Montreal. We found a cute cafe that served Mid-Eastern food. After some yummy chicken with vegetables, couscous, and pita bread, we were refreshed and headed back to the ballroom to hear the recalls announced. I was sad when I didn't hear Katie's number called. From the corner of my eye, I saw her quietly get up and leave the ballroom. Her dad and grandma sat there looking stunned. I was sad too, when the young lady with no hair did not recall either. Sometimes it didn't seem fair--everyone works so hard. It

is all so emotional for everyone. When Bridget's number was finally called I breathed a long sigh of relief.

Relieved all the dancing was over, we went for cocktails and a much-deserved glass of wine for Bridget. We headed to the ballroom early to claim some seats, and much to our surprise, things were moving along with the announcements of the scholarship winners. Expecting to be there all night, we were just relaxing when they announced they would be calling Senior Ladies' results up first! We sprung to our feet, slipping on Bridget's dress, with no time to think. I listened, holding my breath. Bridget was called for the top ten! My first thought was to find the same good luck seashell I held my hand last year. I fumbled around in the dress bag pocket and there it was. Clutching it in the palm of my hand, I ran up to the front and center, Sonia close behind. We found two empty seats in the front row and we sat and listened and watched Bridget beaming up on stage as we waited. The top ten were called up front. And then the top five announced- Bridget was in it!!! I could not believe it and neither could Bridget! Her facial expression was priceless. I sprung from my seat. At that point in time I felt like I was the only person in the ballroom. I heard everyone screaming and shouting. But mostly all I could hear was my cries of happiness. I screamed FINALLY! FINALLY! FINALLY, she is on the podium! I bawled like a baby. I looked down at this little kid next to me--I don't know if it was a boy or a girl--who looked up at me with such a face like, "What a crazy lady," but I didn't care. I just kept crying and laughing and watched Bridget step up to 5th place on the podium with her sash and her prize and a pair of socks! Yes, the top five got a pair of socks! So, funny. Bridget didn't know what to do with all her prizes. As she tried to pose for the pictures, she fumbled around with tears of happiness rolling

down her face. The first and third place winners saw her fumbling and they both smiled at her. Bridget proudly wore that sash around Montreal for the next two days. Someone actually ask her if she was Miss Canada when we were in Old Town. J'aime Montreal!

One More "O"

AFTER MONTREAL, BRIDGET realized that her dancing was at its peak and decided to keep going. A longtime friend of hers who quit a few years back after winning her Oireachtas warned Bridget it was best to quit when she was on top. When this friend learned that Bridget was going to compete at All-Irelands and the "O" one more time she warned her, "Do not let them beat you!" Bridget took that warning to heart--I never saw her so determined and focused. When she left for the All-Irelands without me, I was fully confident everything would be fine. Her workshop teacher would be with her the whole time. I was glued to the computer at 4 am that morning. I was so excited to see Bridget side stage live for her line up. I got texts that said all of her rounds were perfect, including her traditional set, which she was nervous about. Then I saw a great picture of Bridget and her workshop teacher holding hands and hugging each other closely with big smiles on their faces. Another long-time goal had been met—top ten at the All-Irelands!

With excitement in the air from the All-Irelands, competing in a few more Feis before the "O" seemed like the logical

thing to do. I was way past the tears from "The Last Feis" way back when, so we just went and happily enjoyed the time together. Packing the man bag, polishing shoes, carefully cleaning the tanner and makeup off the dress, there was no stress. Nothing mattered at all--only that she loved dancing every second, like she never wanted it to end. Fittingly, she won the competition and came home with the biggest perpetual trophy anyone had ever seen. It is proudly displayed in the living room on the mantle place, the top of it touching the ceiling.

"8-8-8-?"

A FEW WEEKS before the Oireachtas, Bridget woke up from a sweaty, heart-pounding nightmare. As she walked past my room, she saw that I was awake and climbed in bed with me. I could see she was upset. She asked me right away, "Do you think it will happen again? I dreamt I got 8th place AGAIN!" Relieved that was all it was, I smiled and said to her, "That would be a nightmare!" I truthfully added that I did not know. It seemed that the last few Oireachtas did not go in Bridget's favor. She went from 2nd place to 4th to 8th and 8th again and again. It could happen. I told her if she danced like she had been dancing lately and the stars aligned with the earth and the moon in her favor, she should be able to get back on the podium. I told her to concentrate on her dancing and not her placement and everything would be fine. But I was thinking about how awful it would be if she placed 8th four times in a row.

As I was unpacking again in the hotel in Philadelphia, this time there was a calm feeling between myself and Bridget. It was as if everything from polishing her shoes to checking her rotation in the journal was moving in slow motion. As she put

tanner on her legs and I put new laces on her shoes, we talked softly, like we did not want this moment in time to end. I hung up the phone after making the 5:45 am wake up call, and it seemed like that moment was suspended in time. It was truly the last night before the Oireachtas ritual for us.

We were early to rise. The same routine was strangely quiet but happy and controlled. We headed off to the ballroom. As usual, we were the first ones there. Front row. Left side. Feis Dad and Sonia by my side. The competition started at 8:00 sharp. Her dancing was just beautiful. Her smile captured everyone's attention. I was feeling so blessed to see her dance one more time on stage. We had a long day of dancing and waiting for results (of course the Senior Ladies danced first thing in the morning but their results were last at 10 pm.) It seemed like the longest day ever. Feis Dad and I are getting to old for this.

Finally, the results! Bridget was in the top ten! Then called for the top five! The 8-8-8 curse was broken! Standing tall and proud, she accepted her third place sash with her beautiful smile and stood on the podium, beaming with pride and a tear of happiness in the corner of her eye.

CHAPTER **25**

"An Amazing End to an Amazing Year"

IMMEDIATELY FOLLOWING THE Oireachtas, Bridget was busy with the next chapter in her life. She sent her resume and audition video to the two big shows, Riverdance and Lord of the Dance. While waiting to hear back, she took a job with a show called "Christmas with the Celts," a Nashville-based rock band touring the country for Christmas. Think Christmas, rock and Irish music as seen on PBS a few years back. Bridget coordinated the local dance schools to dance in the shows and she had the honor of dancing as the lead in each show. I was lucky to be able to follow the tour through the tri state area. The first show I saw was in Bethlehem, Pennsylvania at the Steel Stacks. The venue was an amazing space with a two-floor wall of glass behind the stage. The impressive Steel Stacks were right outside the windows, backlit by the winter sunset. Once it was dark out, the Stacks were highlighted with subtle neon strings of lights. It was a very unique space.

As I searched for a spot in the back of the hall, the tour

manager gave me my backstage pass. I watched Bridget working with the dancers on stage during the sound check. She looked very comfortable in charge. The show was so much fun, with lots of clapping and singing along. There were even some Beatles songs. The band was amazing. The dancers were all Senior Ladies, very professional, all in Riverdance-style dresses. The biggest compliment Bridget ever received was from one of the dancers that day--she said Bridget reminded her of Jean Butler dancing on stage in her soft shoe dance. She stood out in her little gold sequin dress as lead dancer.

The next morning, we were off to Connecticut. The Ridgefield Theater was beautiful and cozy, a big contrast to the Steel Stacks. As Bridget greeted the local dance school, I sat in the back of the theater. The band did their sound check and Bridget reviewed the routine with the girls. They were a much younger group in their early teens. All their moms gathered in the back and quietly went to "work." One did the dancers' hair, one did the makeup. When we moved to the dressing room, one mom was assigned to do the costumes, tying big red satin sashes to the dancers' waists in perfect big red bows. The girls looked like Christmas presents, so festive and fun. It was a very professional group of moms. They reminded me of an episode of "Dance Moms," minus the drama.

The next show was in New Jersey in a theater near home. Bridget invited her own dance school to do the show. The whole time driving there from Connecticut, I was trying to figure out if I could get red satin ribbon and copy the big red bows. We stopped at a Michaels we passed on the way.

There were no dance moms backstage, just me running around trying to make bow sashes. As I settled into the nice

dressing room complete with big mirrors with lights all around, I got to work with the bows. I peeked out to see the sound check going on, the dancers on stage practicing, and Bridget in the center of the auditorium sitting by herself watching everything going on. I could tell by the look on her face that she was pleased by what she was seeing on stage. She looked like a future Irish dance teacher, aka T.C.R.G. / Choreographer. I snapped a photo and then went back to work.

The show was so much fun. Everyone was clapping and singing along. At one point, I turned to see Grandma singing along and clapping to a song. She NEVER sings or claps to anything. The show was that good. Then as quickly as the last song ended before the intermission, my phone got numerous texts in a row. It was Bridget. "Need your help backstage, now." I navigated my way back to the dressing room to find Bridget in a panic. Her little gold sequin dress had a V neckline. It had opened up in the last number and almost let the "girls" out. She said to me "Ma man bag sock glue safety pins" and without a word I took command and sock-glued the v neckline to her body and pinned it with a safety pin. Good old sock glue to the rescue.

The next day was Bridget's last show with the Celts. It was a Grand Finale. It was at the Iridium Theater on Broadway in New York City, steps from Times Square, in an old Jazz supper club. We were greeted by the owner and we followed him around the stage thru dark skinny halls to the dressing room. It was filled with small tables, chairs, old booths, suitcases, boxes, and lots of "stuff." On the walls were posters and signed pictures of famous people who played there through the years. There was no room to put our things down. We piled our coats and Bridget's shoe bag and little gold sequin dress on top of the pile. One band

member was sleeping in the corner. The charming fiddler from the band was putting curlers in her hair while some of the dancers watched. This group of dancers was much younger, all dressed in their schools costumes they use just for shows. There were eight of them, all with their moms, dads, and teachers. It was packed backstage.

When it was time for the sound check and rehearsal, I put my backstage pass on (yes, I am a groupie now. I love the band!) I went to the little 1960s style bar in the corner of the club. It was so cute, decorated with tinsel and little red bows and gold bells for Christmas. It reminded me of my grandparents' house at Christmastime. I paid fifteen bucks for a Jameson and ginger ale. I sat and sipped my drink watching Bridget go over the routine with the dancers and work with the band. The show was great. I sat alone at the cozy bar watching the whole time. When it was over, the owner brought out enough trays of delicious food for a large crowd and we all ate together--the band, the parents, the dancers, and the workers. The owner made sure we were all full and happy. Then, the band and the dancers and Bridget all did the show again as if no one wanted the night to end. All the parents lined up snapping pictures on their phones like the Paparazzi. The owner grabbed a bottle of scotch and an armful of glasses and danced around, pouring shots for us while he was singing to the Beatles song "Happy Xmas War Is Over".

Later, the music and the dancing quieted down, the dancers exhausted. Bridget said goodbye to her new friends. By the time we found our coats and Bridget's shoe bag, it was midnight. The lights were being turned off in the club as we walked out into the cold winter air on Broadway. Bridget took off her coat and asked me to take a few pictures of her in

her little gold sequin dress in front of the Iridium with Times Square in the background, just around the corner from Radio City Music Hall where it all started when we saw Riverdance all those years back. "What an amazing end to an amazing year," she said as I snapped the photo.

Judges' Comments or "Beats a bit fuzzy"

KNEES BENT. TIRED at end of set. Excellent grace and style. Watch ending. Lovely S.J. Rhythm could be stronger in set. Nice reel. Nice set. Arms. Got tired. Close knees. Lovely reel. Arms in. Higher rocks. Lovely arch. Loose knees. Rocks need work. Great control and rhythm. Shame great set. Stronger beats. Nice energy. Ending unbalanced. Beautiful reel. Fell off toe. X feet more. Clean watch placement. Relax head hold. Wonderful reel. HP could be stronger. Nice light. Good display of steps. Excellent. Lovely dancer. Stylish. Nice light. Beautiful Points! Stamina. Great feet. Ex .style. Ex execution. Nice. Lovely. Excellent performance. Keep shoulders back. Beats unclear. Turn feet out. Sharp reel. Very elegant. Some batters weak. Lovely reel-great "life". Sharper arch. Good. Very nice and smooth. Lovely clicks. Try to get more sound from batters .More turn out. Close rocks. More spring in set. Extends well. Nice set. Cross feet more. Music bit fast? Lovely. Nice control. Watch balance. Watch end. Feet straight. Great soft. Set crisper. Nice job. Watch pointe at end of set. Nice

style. Elbow. Dropping heels. Placement. Lighter on jumps. Watch timing. Off heels in set. Rushed at times a bit still in parts. Too much side in light. Hiding? Straighter legs. Slap trebles. Graceful. Toes out more. Set was a bit disappointing not strong enough. Pull shoulders back. Neat. Very nice reel. Arms wide. Lost steam at end of set. More control. Clear beats. Well done. Balance. Trip>. More attack. Keep body straight. Keep it going till end! Good loose ankles. Lovely dancer. Good job. Solid set. Well done. Nice style. Beautiful reel. Close knees. Carriage. Tired near end. Bending. Keep left arm in. Good set. Nice style but no attack. More sound. Natural style. Pace to end. Lost steam at end. Ending? No stamina. Heels on takeoff. Timing good. Leaning. Keep energy. Looser ankles. Slipped. X more. Fighting with music in set. More spring in knees. Tripped. Nice neat dancer. Toes out more. Tighter rocks. Faded. Nice but beats a bit fuzzy. Lovely flow. Try not to get stuck in corner. Arms. Rocks. More x. Good rhythm. Mistake end of set. Watch timing. Nice footwork. Lovely reel. Nice set. Cross more. Nice energy in reel. Stamina. More spark in reel. A nice stylish dancer. Lift more. Make clicks. Good set end it neater.

I knew there was a reason I kept every result sheet!

CHAPTER **27**

Priceless

13,125 hours of practice now 14,275
47 pairs of soft shoes now 49
1 pair of pink sparkle shoes for awards
20 pairs of hard shoes now 22
150 pairs of poodle socks now 173
10 pairs of Lucky Buckles
11 pair of crystal poodle socks now 12
17 long curly wigs
3 donuts for wigs
2 bun wigs now 3
8 new dresses
1 Leprechaun dress
5 team dresses
13 bottles of sock glue
1,507 bobby pins
4 trips to England
13 Trips to Ireland now 14
2 trips to Canada now 3
2 trips to Scotland
12 headbands

2 large stone tiaras
8 tubes of Bengay
43 rolls of black tape now 57
19 rolls of white electrical tape now 23
207 results sheets now 210
157 trophies now 159
79 medals now 82
29 pieces of crystal now 30
15 Oireachtas now 16
9 pairs of false eyelashes
350 cans of fake tanner
13 Nationals now 14
9 Worlds now 10
115 thousand miles on minivan
92 thousand miles on Durango
Pockets full of good luck charms
Countless smiles and new friends
Countless tears, hugs and memories
18 Years of Irish Dance now 19
Priceless

And now, I truly understand what Ms. Deirdre meant when she said to me "I hope you have lots of money"!!

Thank You

Feis Dad, for putting up with all the crap.

Sonia for your devoted love and support.
*Miss Kelly for being there from the beginning and
into the future*
And Miss Suzanne Yavuz for your time and knowledge.

*And a special shout out to the cast and crews of both
Rhythm in the Night and The Celts. "Bridget"
knows how lucky she is to have worked with two
amazing groups of people that she will never forget.*

CPSIA information can be obtained at www.ICGtesting.com
Printed in the USA
LVOW11s2303190516

489052LV00001BA/84/P